VILLAGE VOICES

BOOKS BY KIDS, FOR KIDS

I AM THE RAINBOW

NORTH INDIA

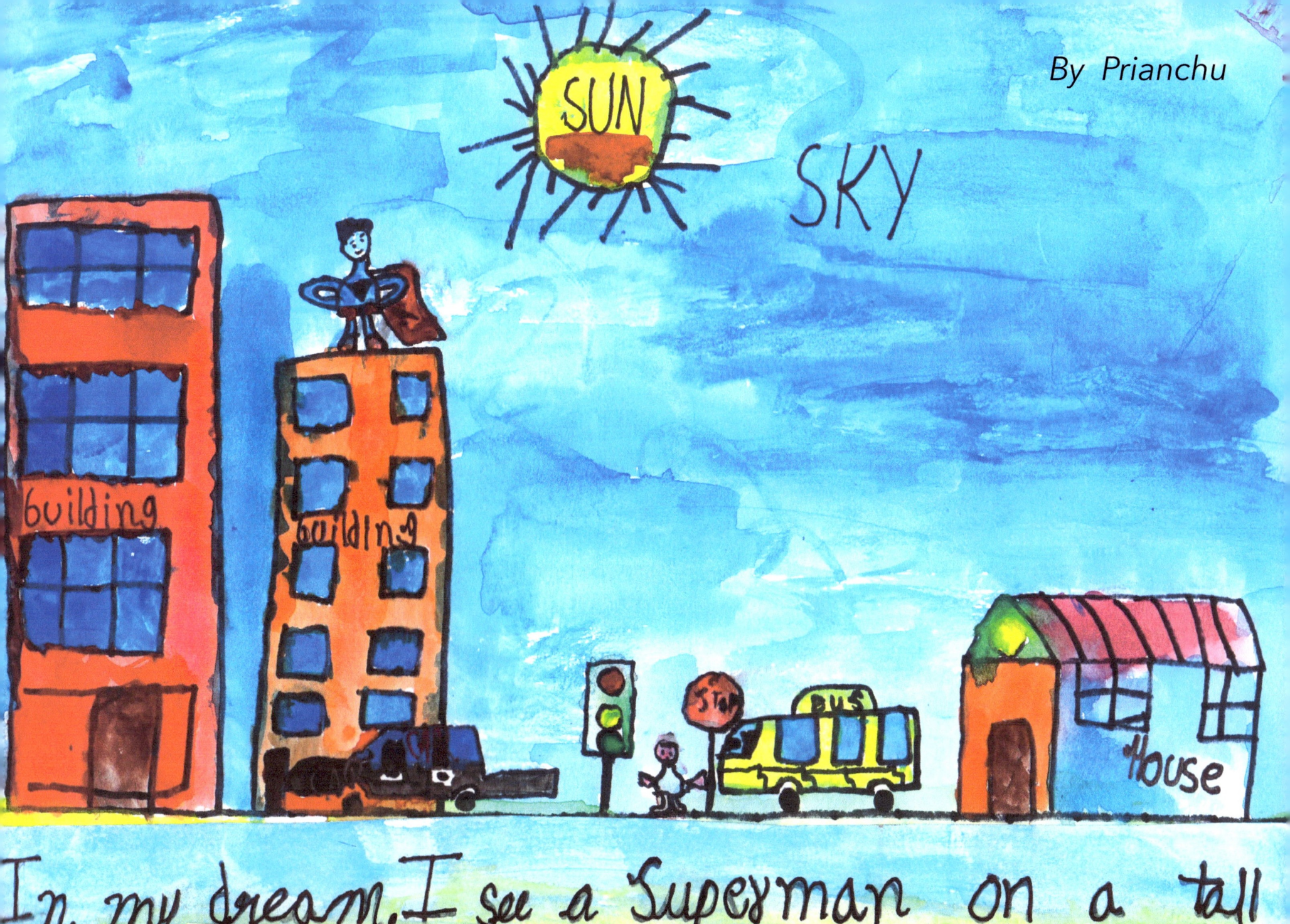

NEW MOON BOOKS
is an imprint of Salt River Publishing
Phoenix, Arizona
www.SaltRiverPublishing.com

Text and artwork © 2016 by Tia Pleiman
All rights reserved. The contents of this book may not be reproduced, stored or copied in any form -printed, electronic, photocopied or otherwise.

I am the Rainbow: North India is made available under the terms of the Creative Commons "Attribution- NonCommercial- NoDerivs 4.0 International" License, http://creativecommons.org/licenses/by-nc-nd/4.0/.

First edition 2016
18 17 16 3 2 1 III II I
ISBN: 978-1533107145

Cover art by Sanjana
Art editing by Kartik Gera

Publisher discount available at
SaltRiverPublishing.com/estore/

Art Therapy (Integral Art) provides a VOICE where one may or may not exist…

I dedicate VILLAGE VOICES to children of all ages… May they be blessed with a voice, a vision, the divine light of creativity, self-expression, a love of books and reading.

"Never forget the goal.

Never stop aspiring.

Never halt in your progress, and you will succeed."

The Mother

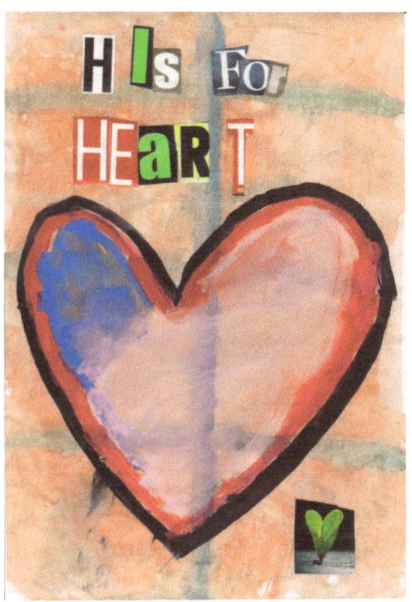

TIA PLEIMAN

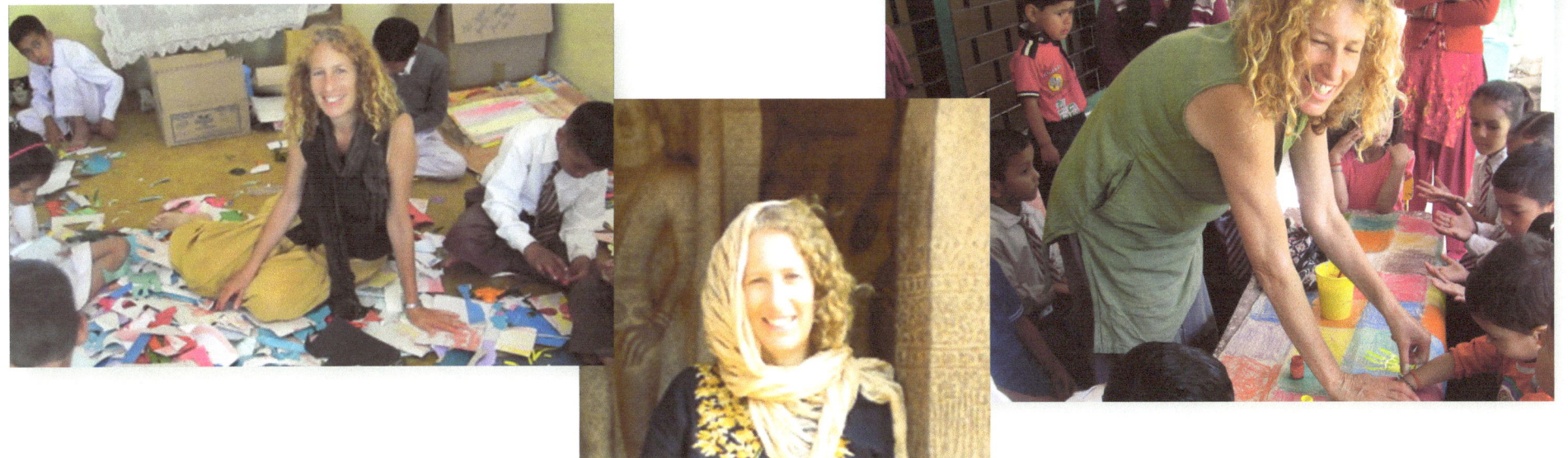

"Village Voices" is a series of books created by village children of all ages. The focus is on Art and Literacy – the result is creative empowerment. The intention of Village Voices is to nurture creativity and self-expression and to inspire a joy for reading.

The project and programs are facilitated by Tia Pleiman, MA, an international art therapist from the USA with 25 years of art therapy and educational experience. For the past 8 years, Tia has been working with urban and village children in north and south India and Nepal.
Tia is passionately committed to facilitating personal growth and development of children, youth and adults through Art Therapy. The tools of transformation are: The philosophies and practice of Integral Education combined with Art Therapy (Integral Art), which serve as the foundation for social, emotional and intellectual development through creative expression, self-reflection, literacy and peace building skills on both an individual and collective level.

THANK YOU for purchasing Village Voices, books by kids for kids. You are helping to support Create and Transform, providing community-based, grassroots Art and Literacy programs and projects, as well as the young authors, artists and schools they attend.

Facebook: Art Therapy with Create and Transform
www.createandtransform.org
tialovesart@gmail.com

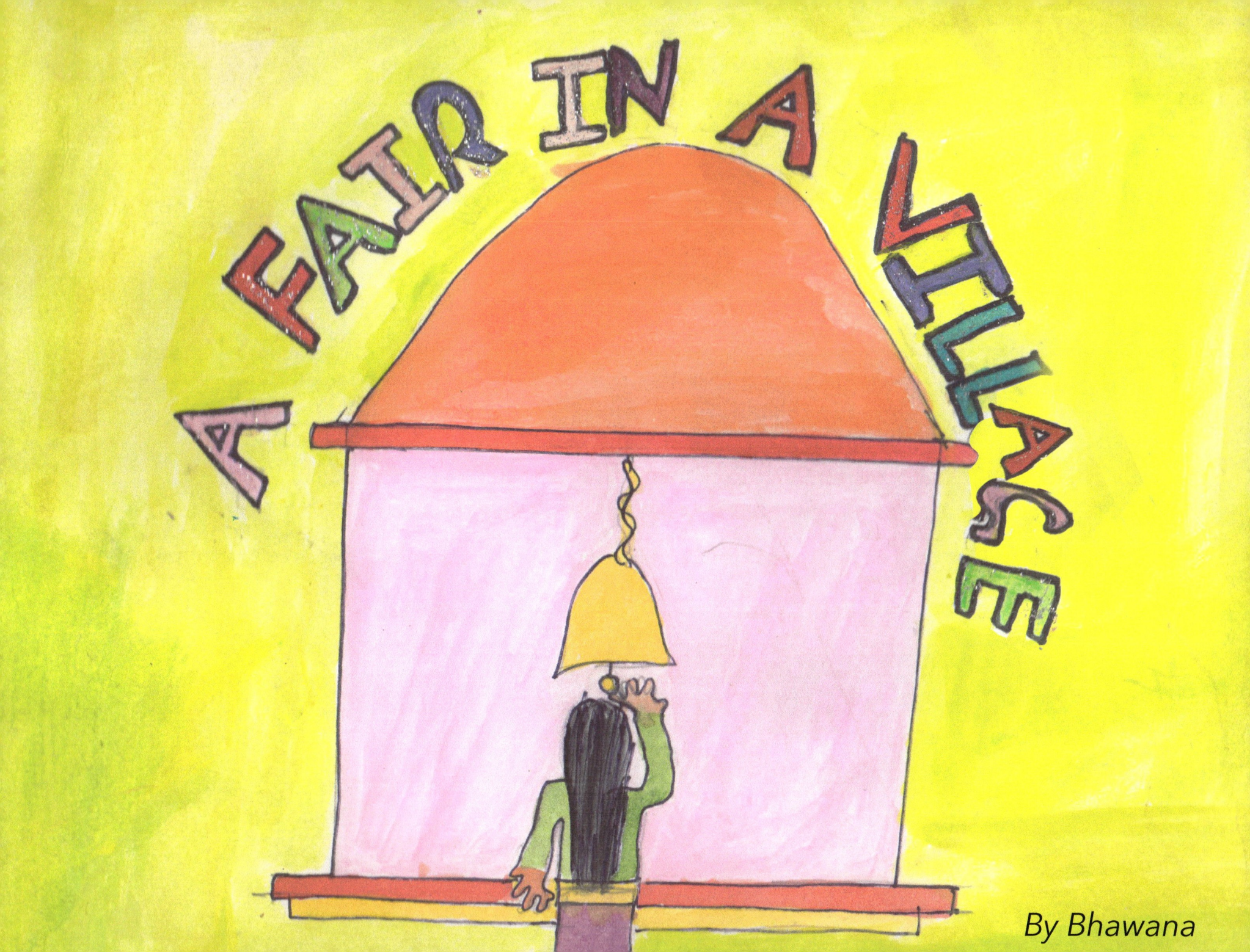

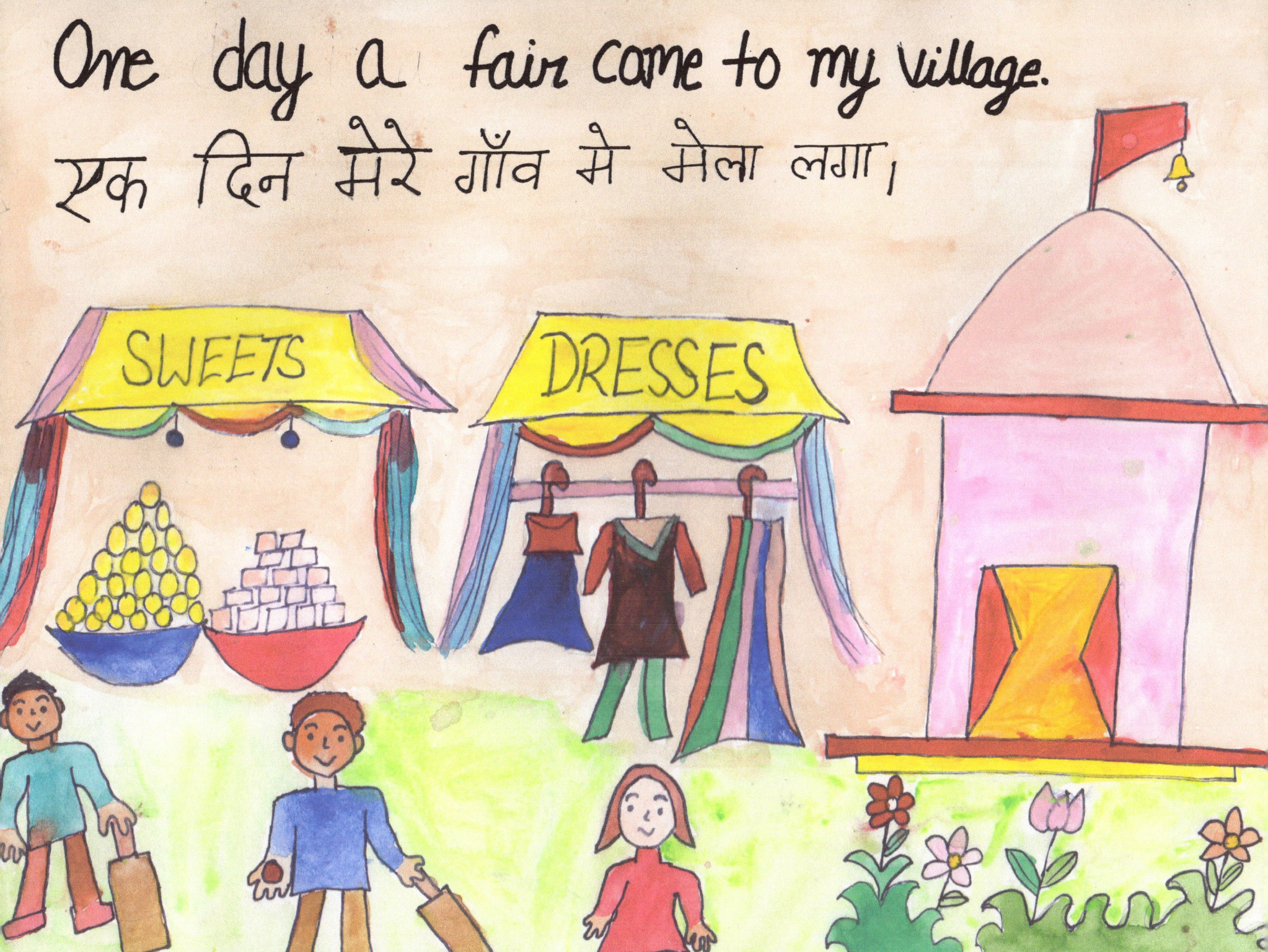

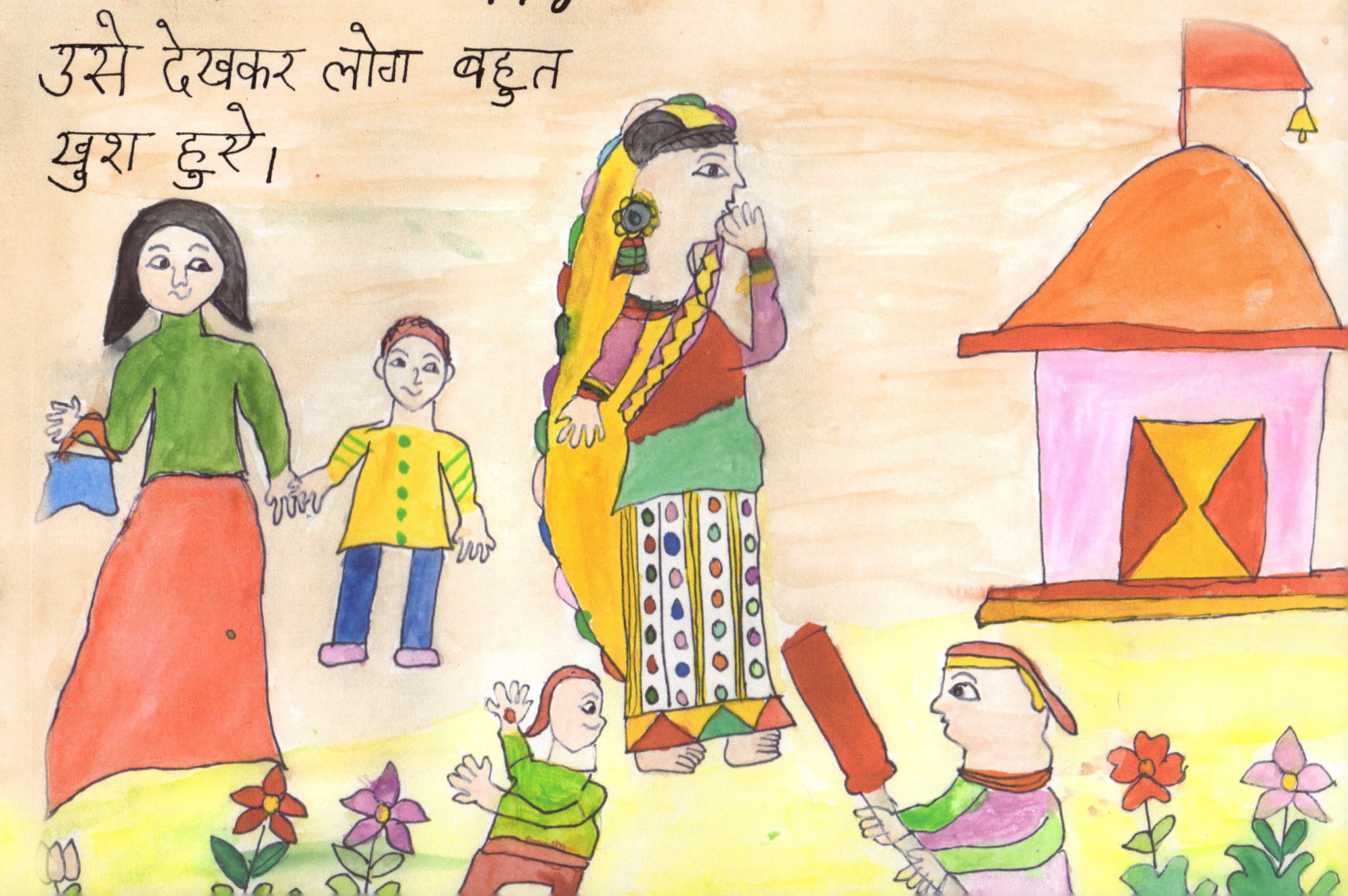

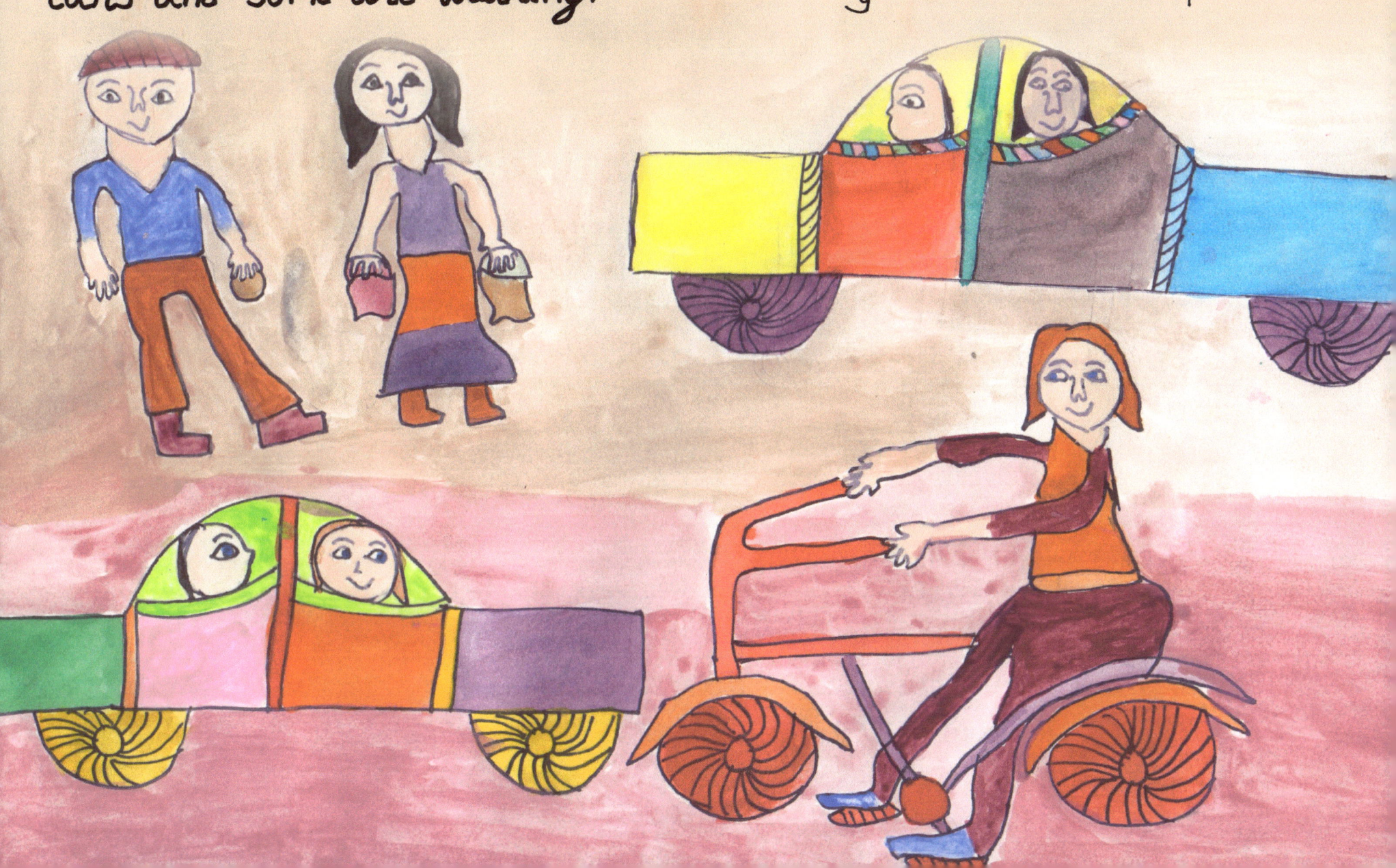

The people are coming by bullcarts some come in rickshaws, some come by cars and some are walking.

मेले मे लोग बैलगाड़ी, रिक्शा, रिक्शा, गाड़ी मे आए, कुछ लोग चल के आए।

There are many sales at the fair. The people buy clothes, sweets and the children buy toys. Mostly the boys buy bats and the girls buy dolls.

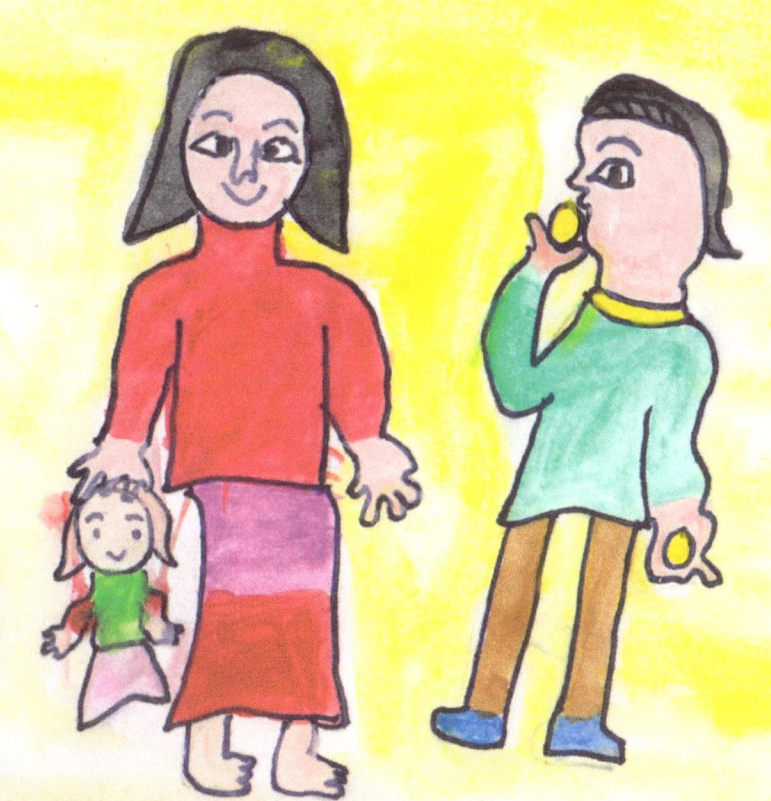

मेले में बहुत सारी चीजें बिकती हैं। लोग कपड़े, मिठाइयां और बच्चे खिलौने खरीदते हैं। ज्यादातर लड़के बल्ला और लड़कियॉं गुड़िया खरीदती है।

The fair is in the temple. There are no rides. The people worship and then distribute prasad.

मेला मंदिर में है इसलिए कोई खेल सवारी नहीं है। लोग पूजा करते हैं और प्रसाद बाँटते और खाते हैं।

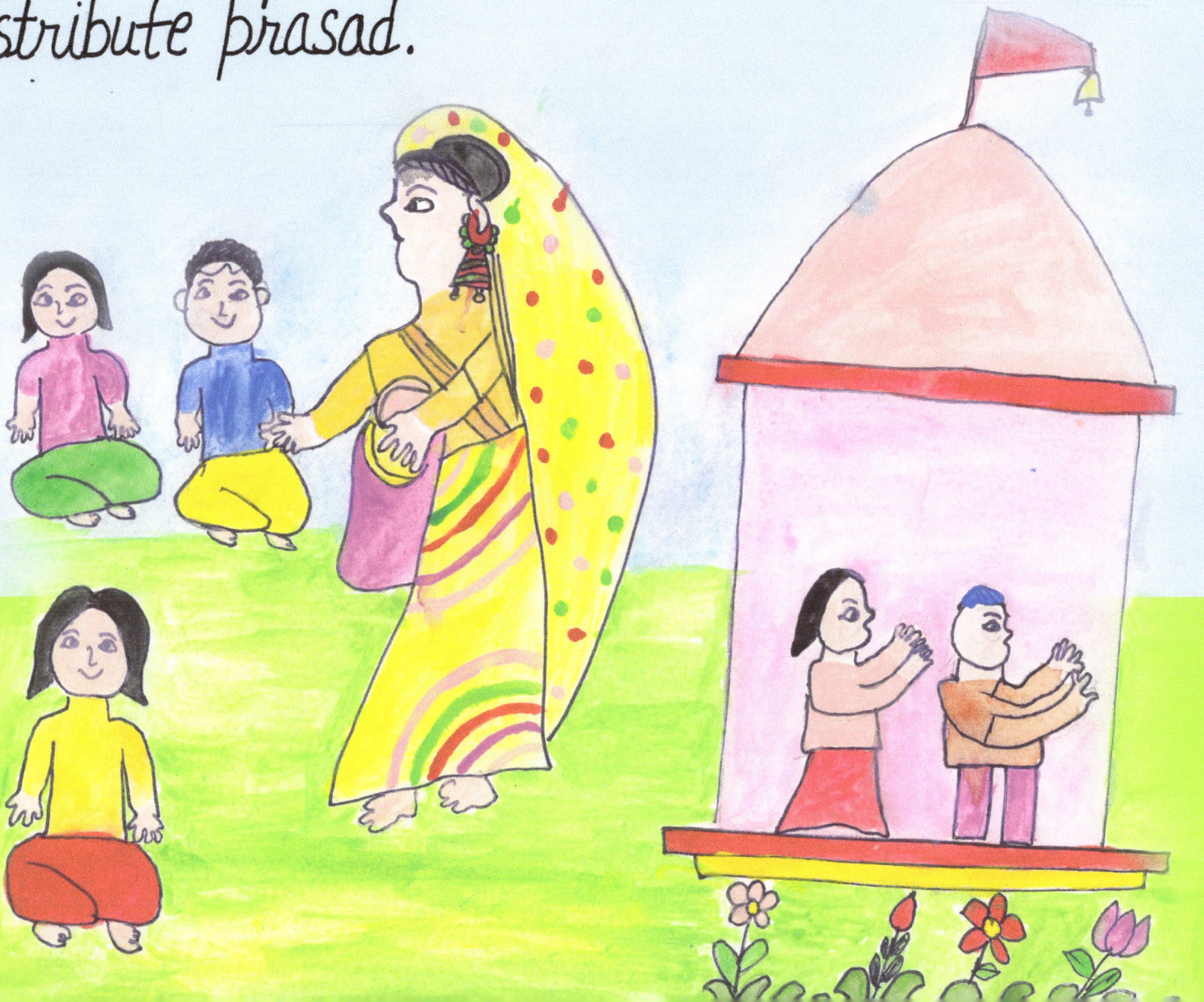

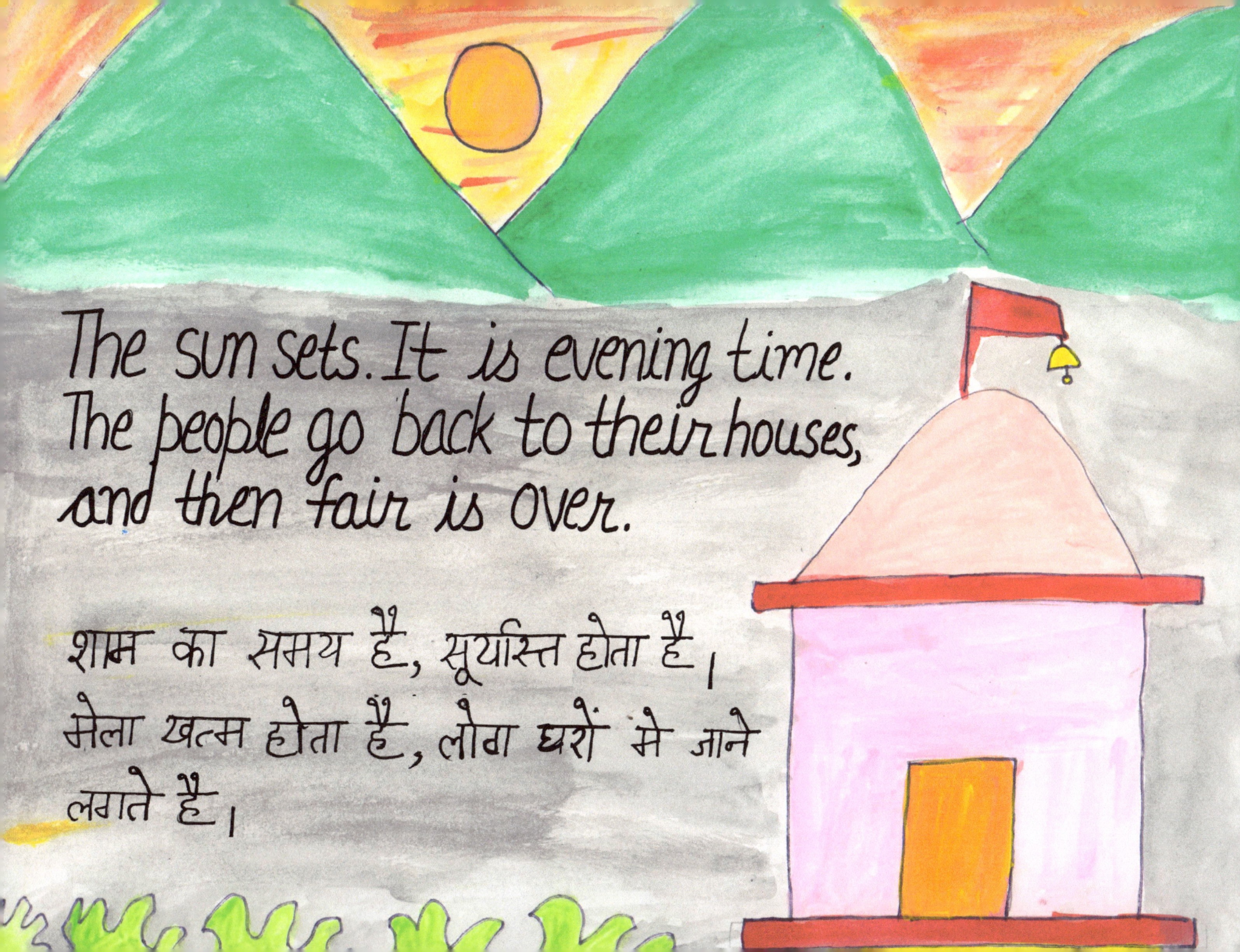

The sun sets. It is evening time. The people go back to their houses, and then fair is over.

शाम का समय है, सूर्यास्त होता है, मेला खत्म होता है, लोग घरों में जाने लगते है।

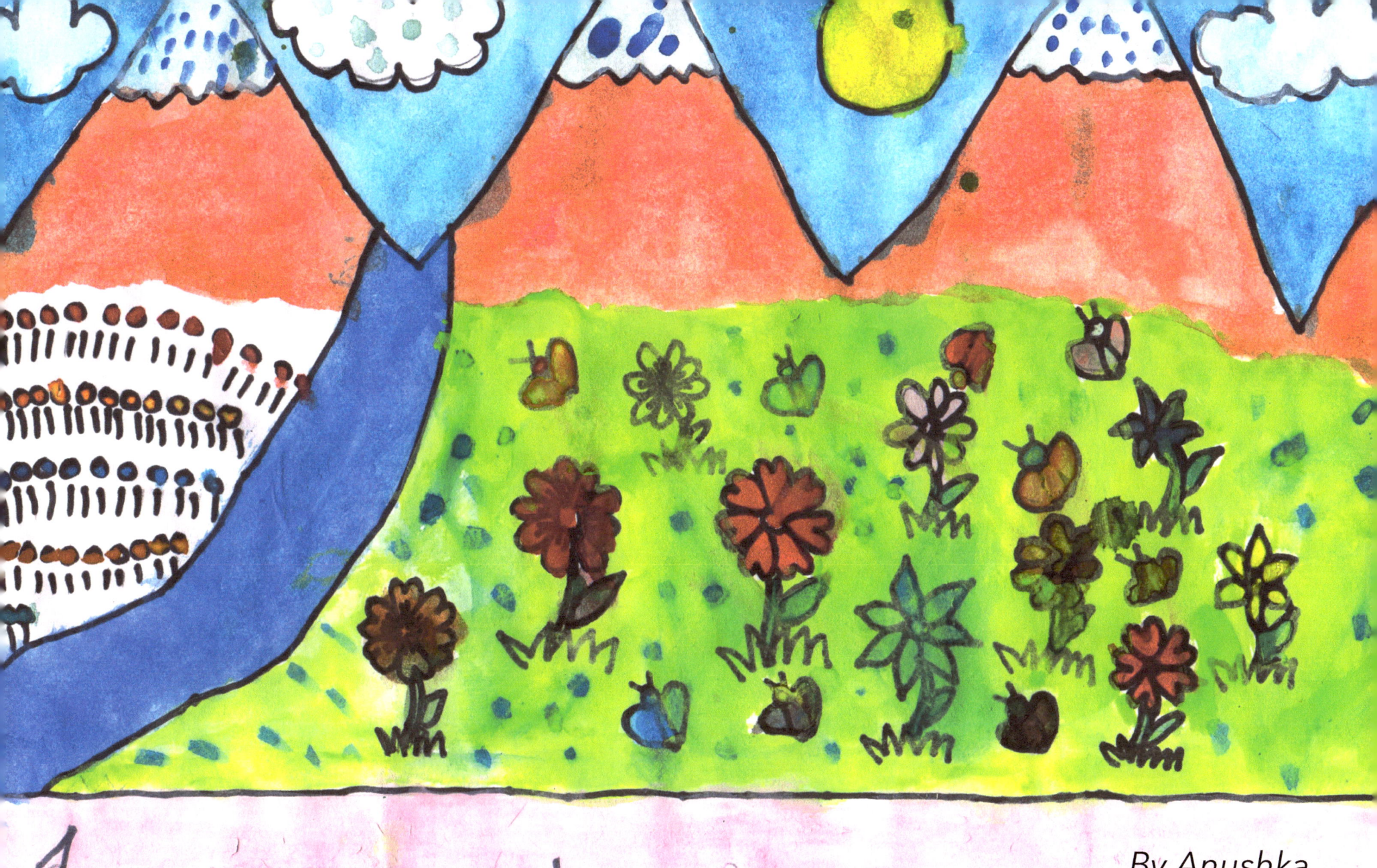

I saw my dream a beautiful place
मैंने अपने सपने में एक सुन्दर जगह देखी।

By Anushka

Collective Art
grades 4 through 8

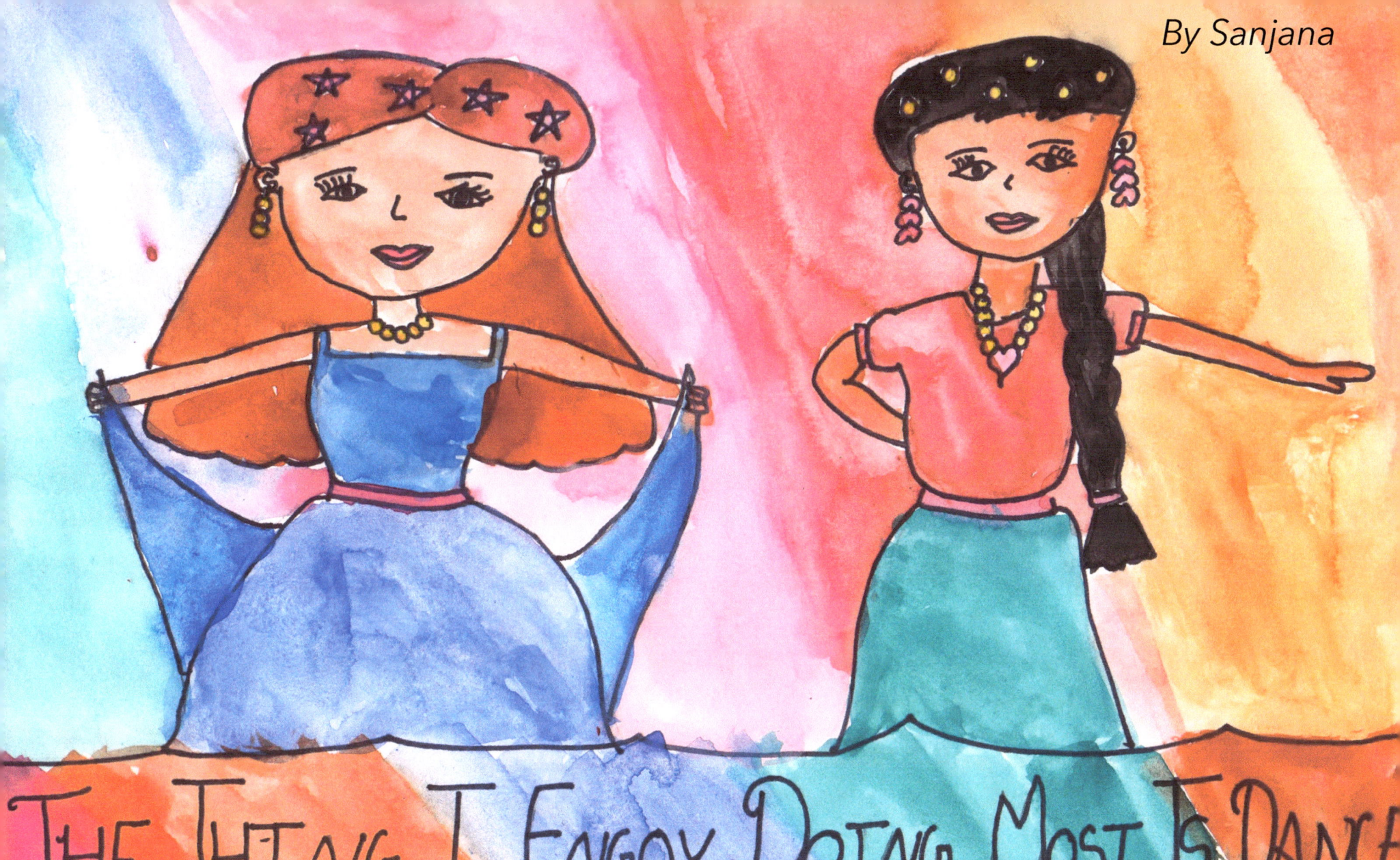

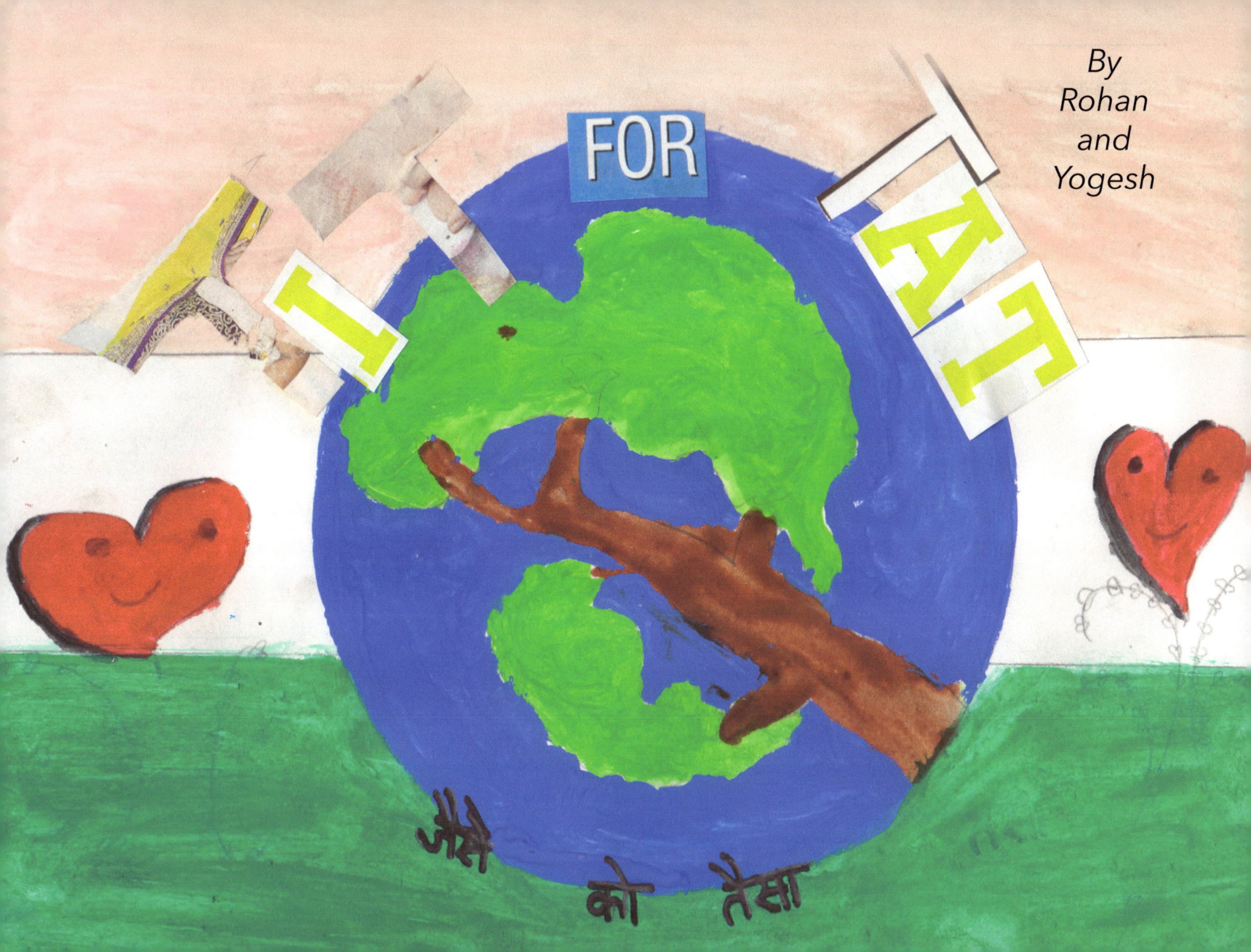

Once upon a time there was a forest with so many trees.

एक समय की बात है, एक जंगल में बहुत सारे पेड़ थे।

One day a man came in the forest and cut down so many trees.

एक दिन एक आदमी आया और उसने काफी सारे पेड़ काट दिए।

Now there are only a few trees left in the forest.
अब जंगल में सिर्फ कुछ पेड़ बचें है।

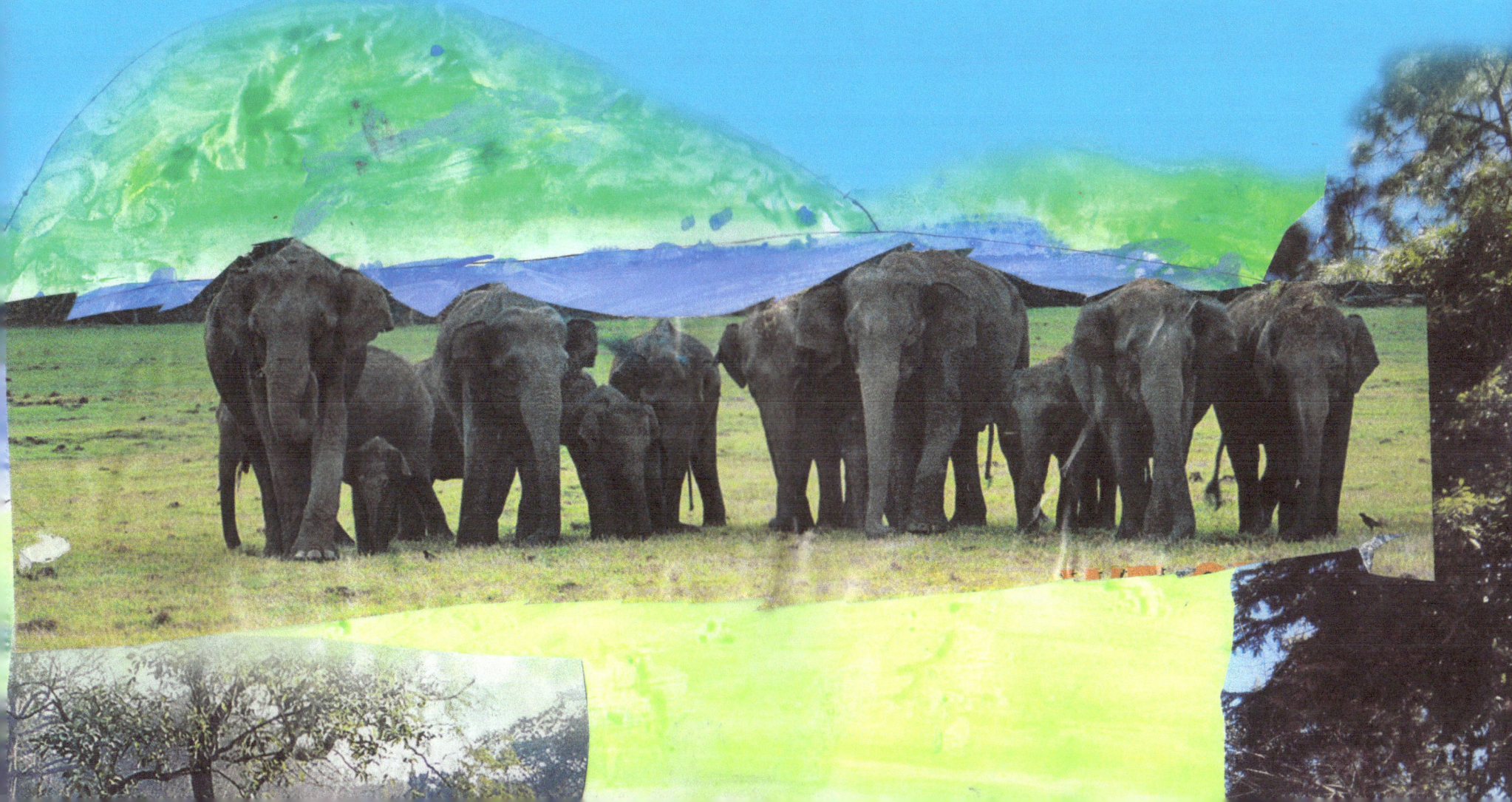

The Forest was now filled with chopped down dead trees. The ghosts of the trees came out.

जंगल अब कटे हुए मृत पेड़ों से भर गया था। पेड़ों के भूत पेड़ों से बाहर आ गए।

The ghosts of the trees were crying saying "we want to find the man that cut us down."

पेड़ों के भूत रो रहे और कह रहे थे "हम उस आदमी को ढूँढ़ना चाहते है जिसने हमें काटा है।"

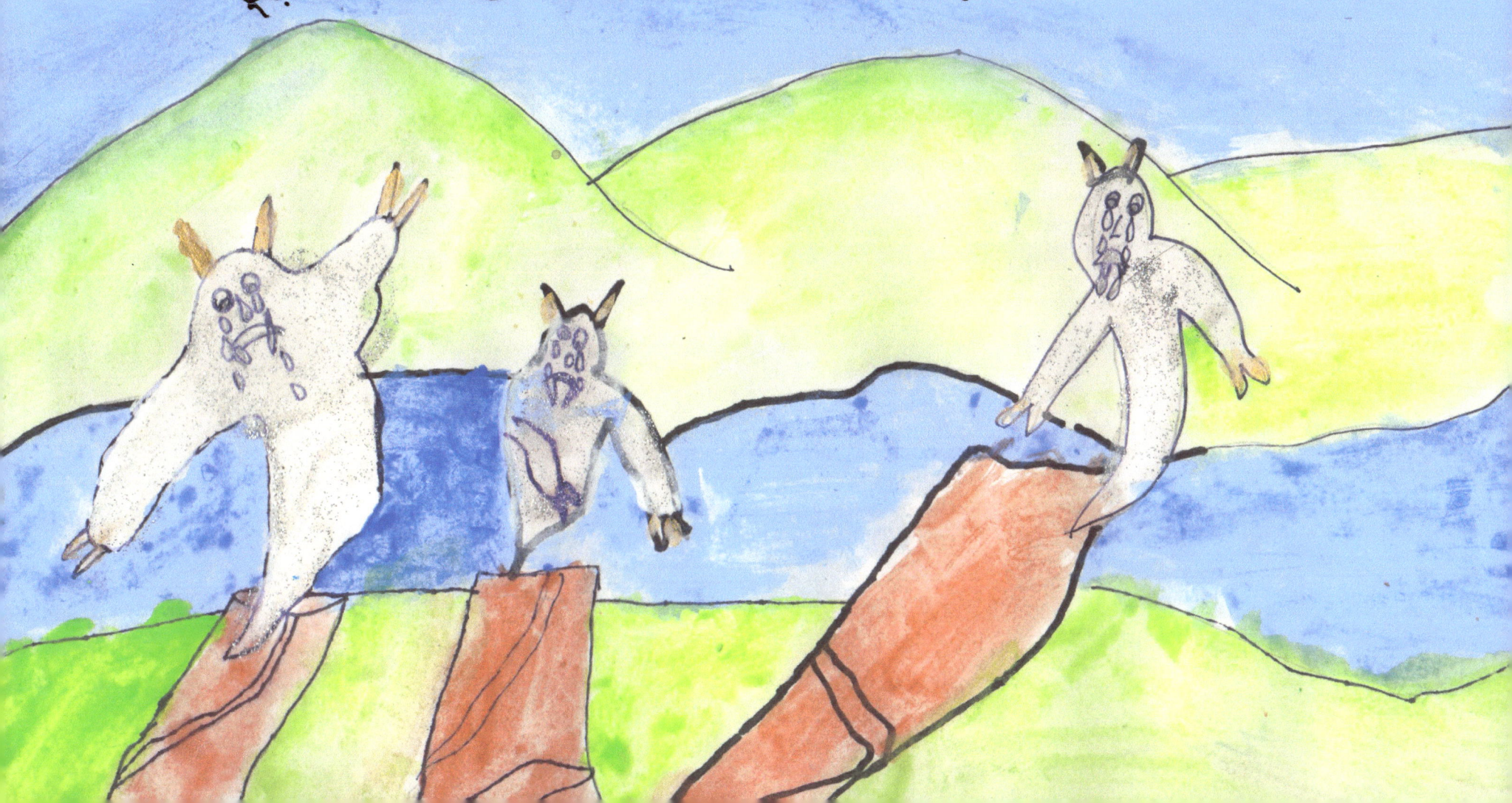

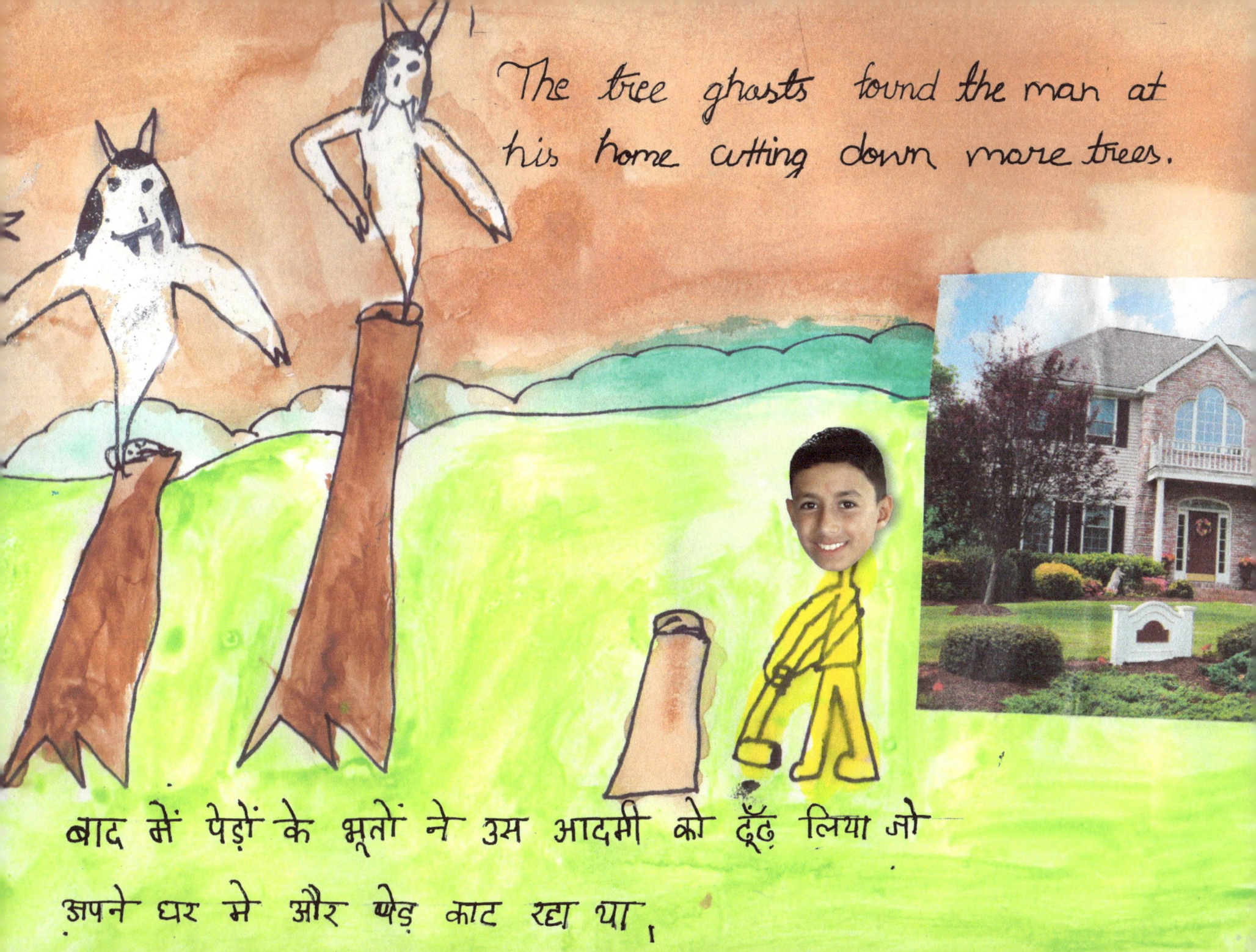

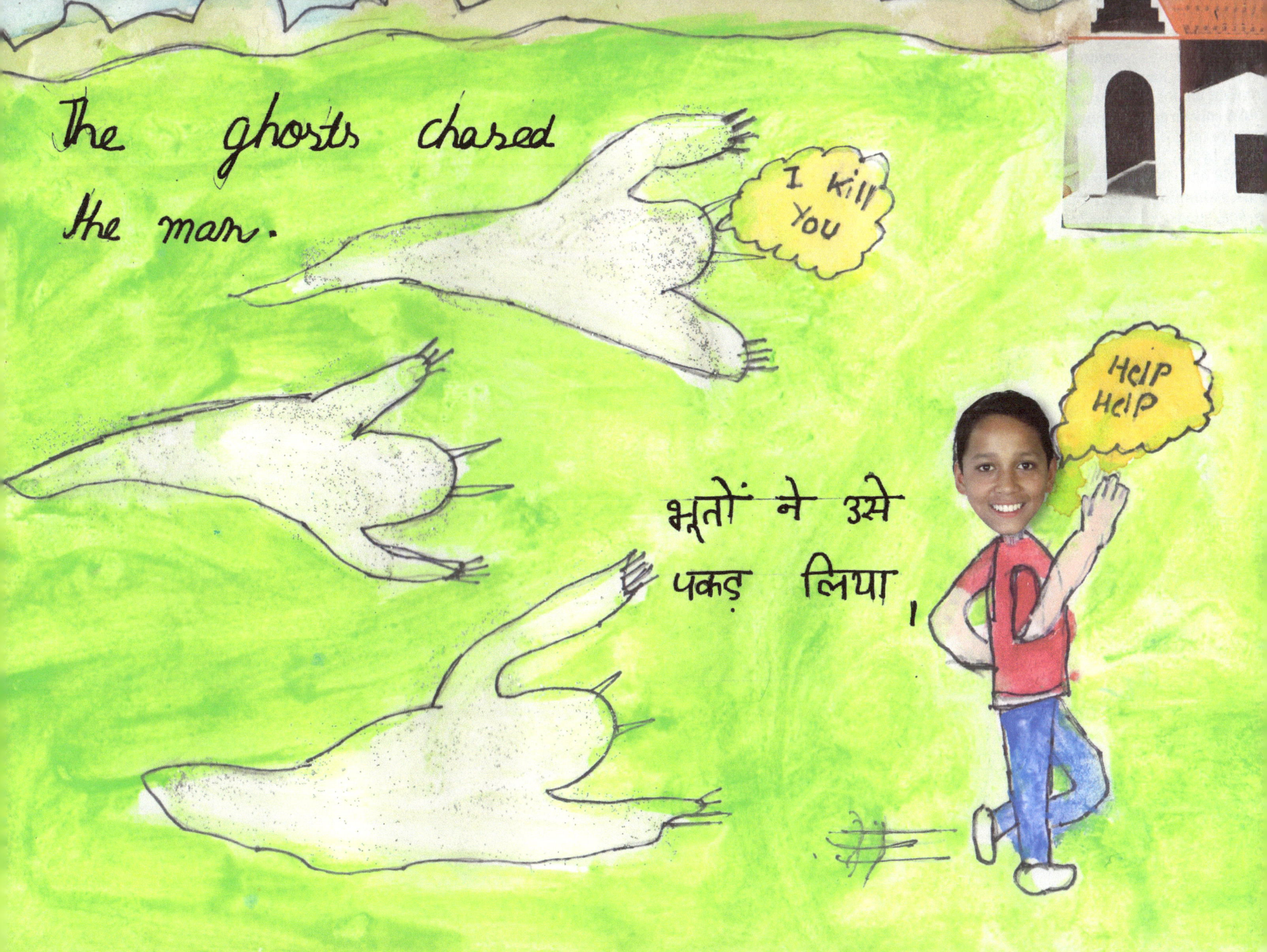

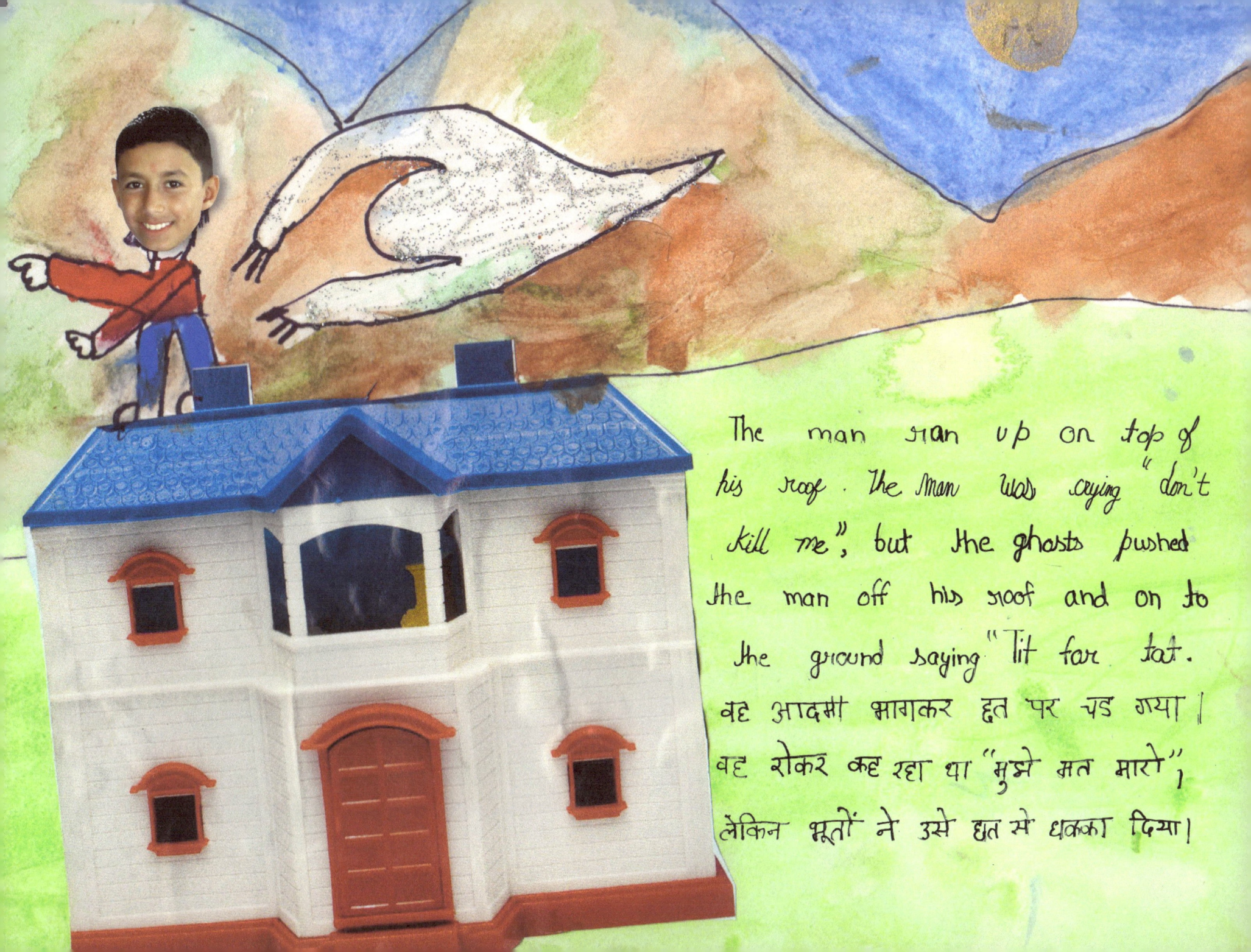

The man ran up on top of his roof. The man was crying "don't kill me", but the ghosts pushed the man off his roof and on to the ground saying "Tit for tat.

वह आदमी भागकर छत पर चढ़ गया। वह रोकर कह रहा था "मुझे मत मारो", लेकिन भूतों ने उसे छत से धक्का दिया।

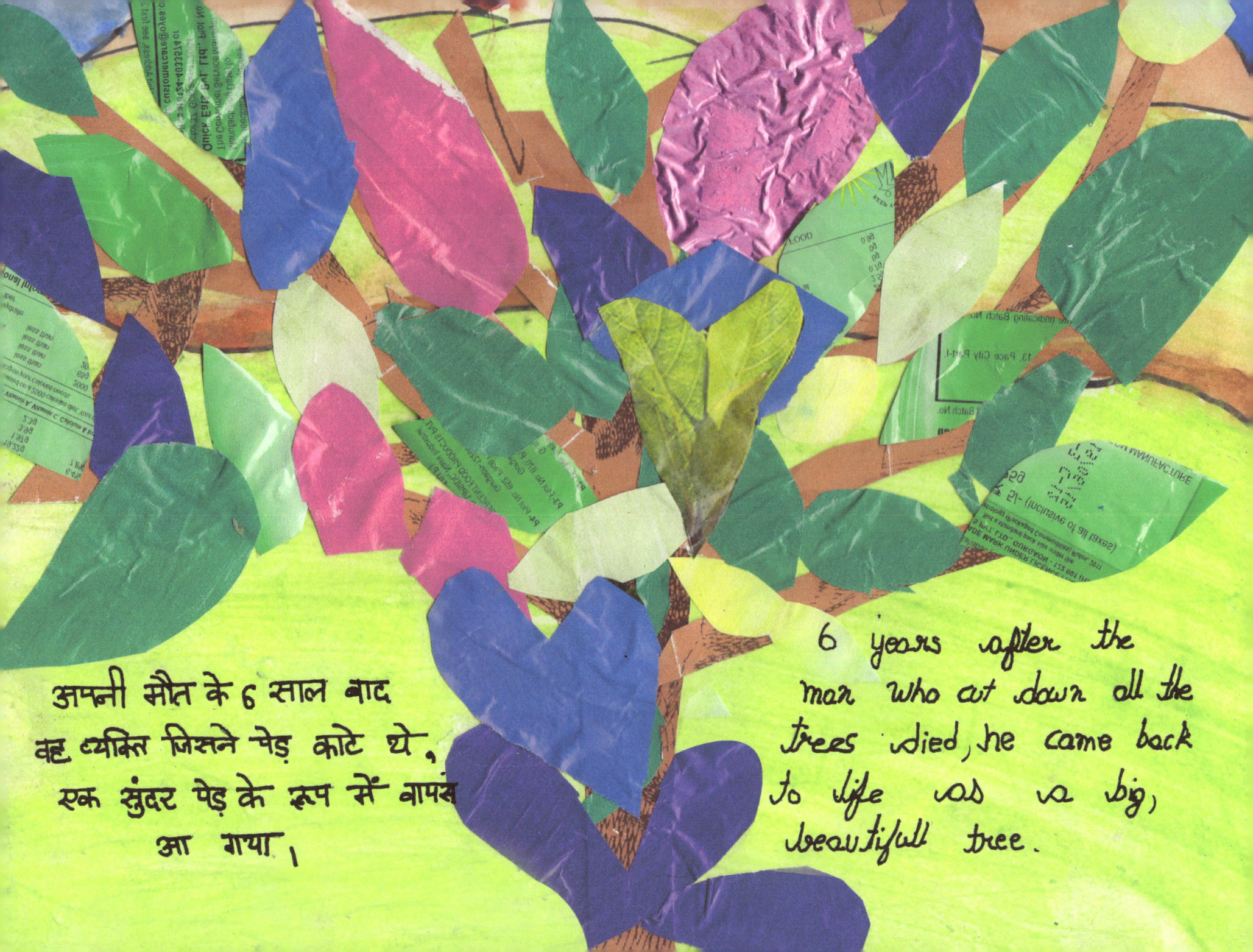

अपनी मौत के 6 साल बाद वह व्यक्ति जिसने पेड़ काटे थे, एक सुंदर पेड़ के रूप में वापस आ गया।

6 years after the man who cut down all the trees died, he came back to life as a big, beautifull tree.

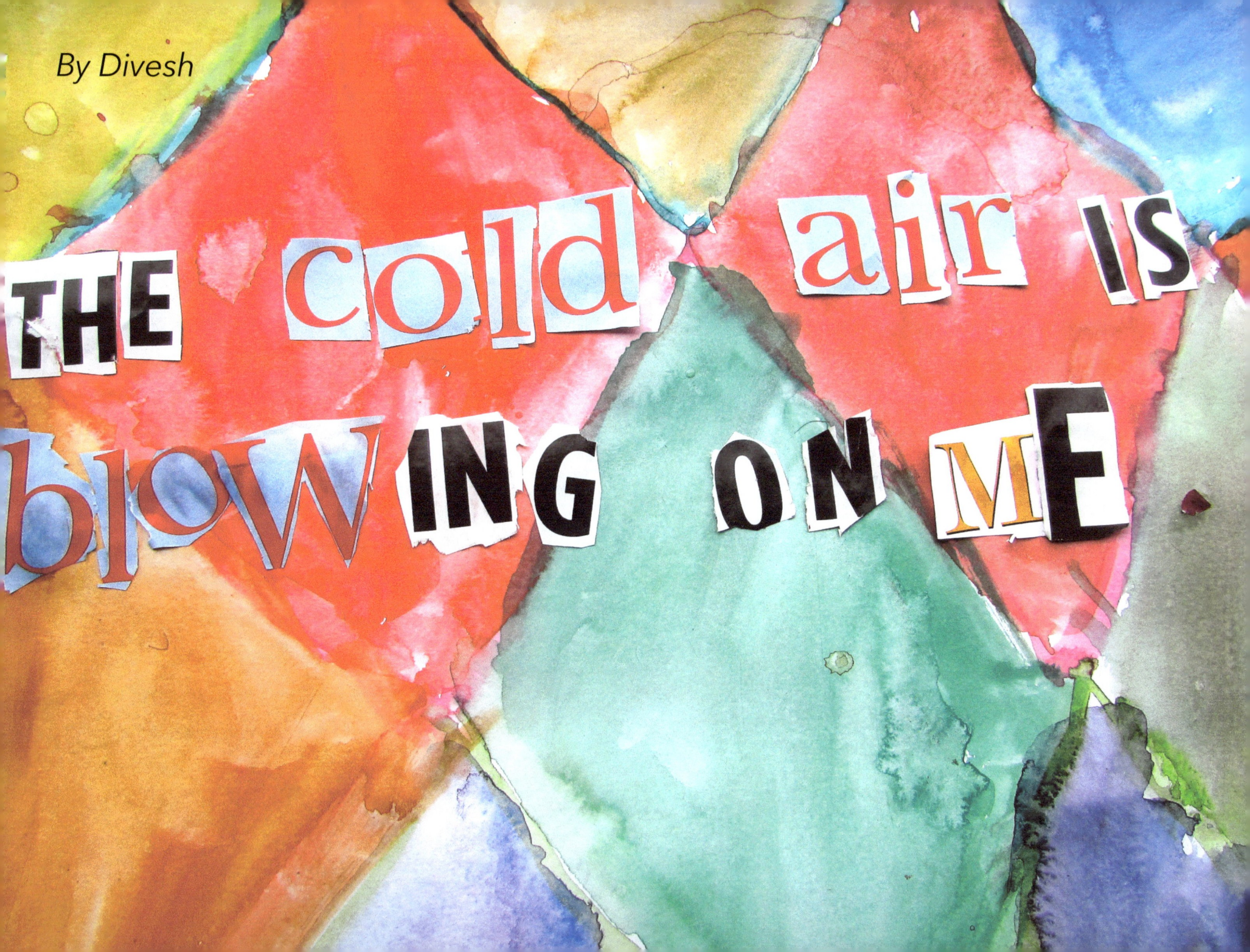

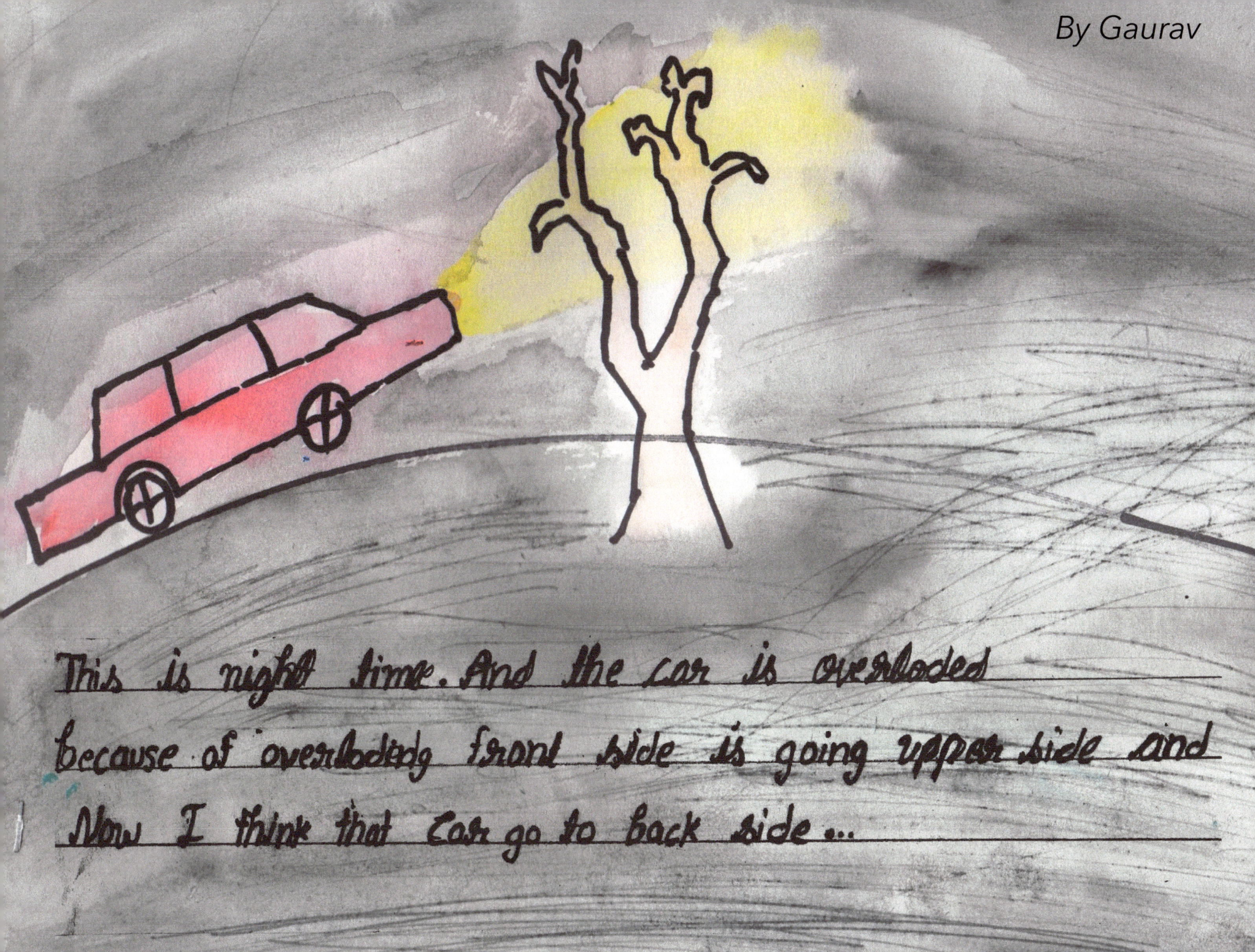

By Gaurav

This is night time. And the car is overloded because of overlodedg front side is going upper side and Now I think that car go to back side...

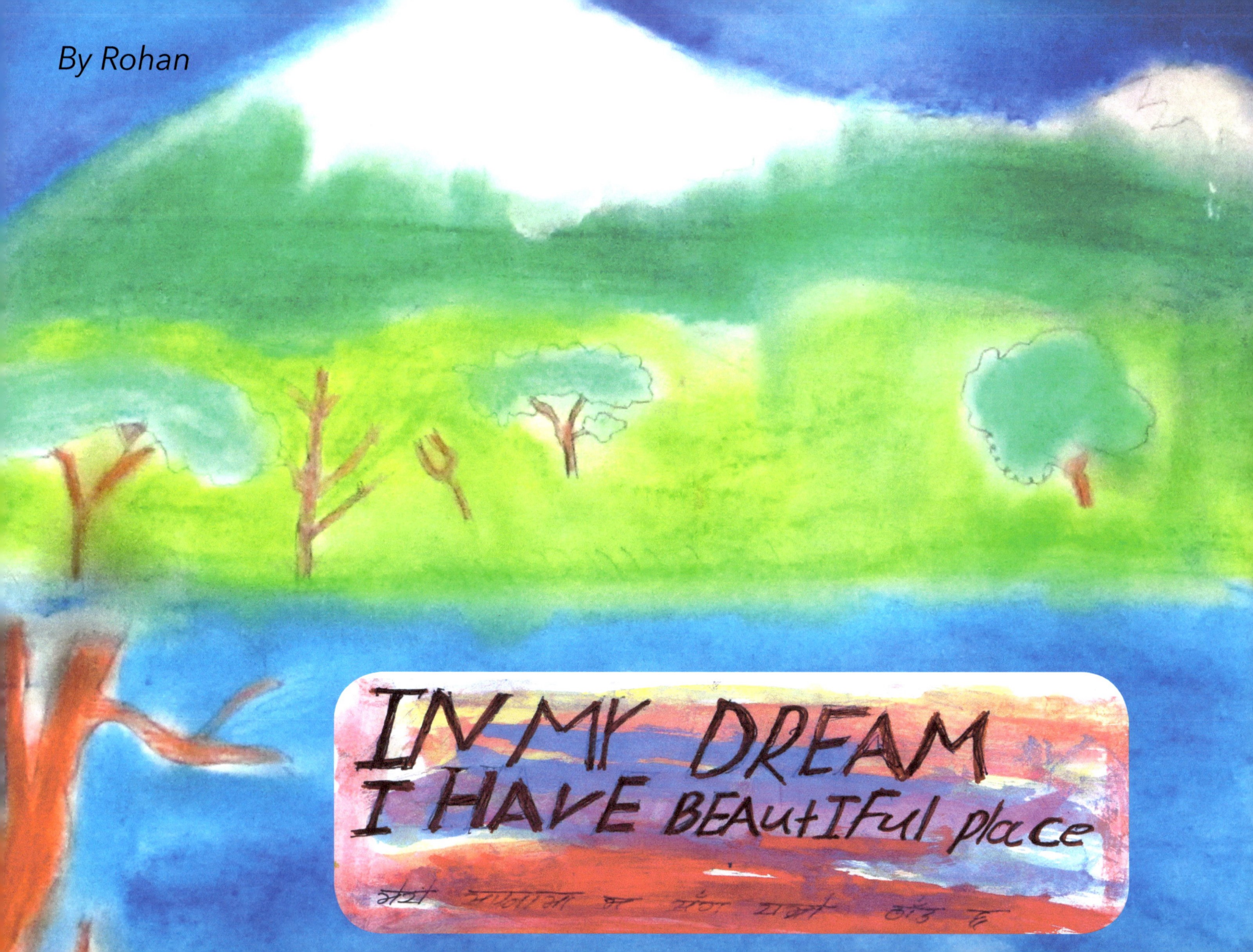

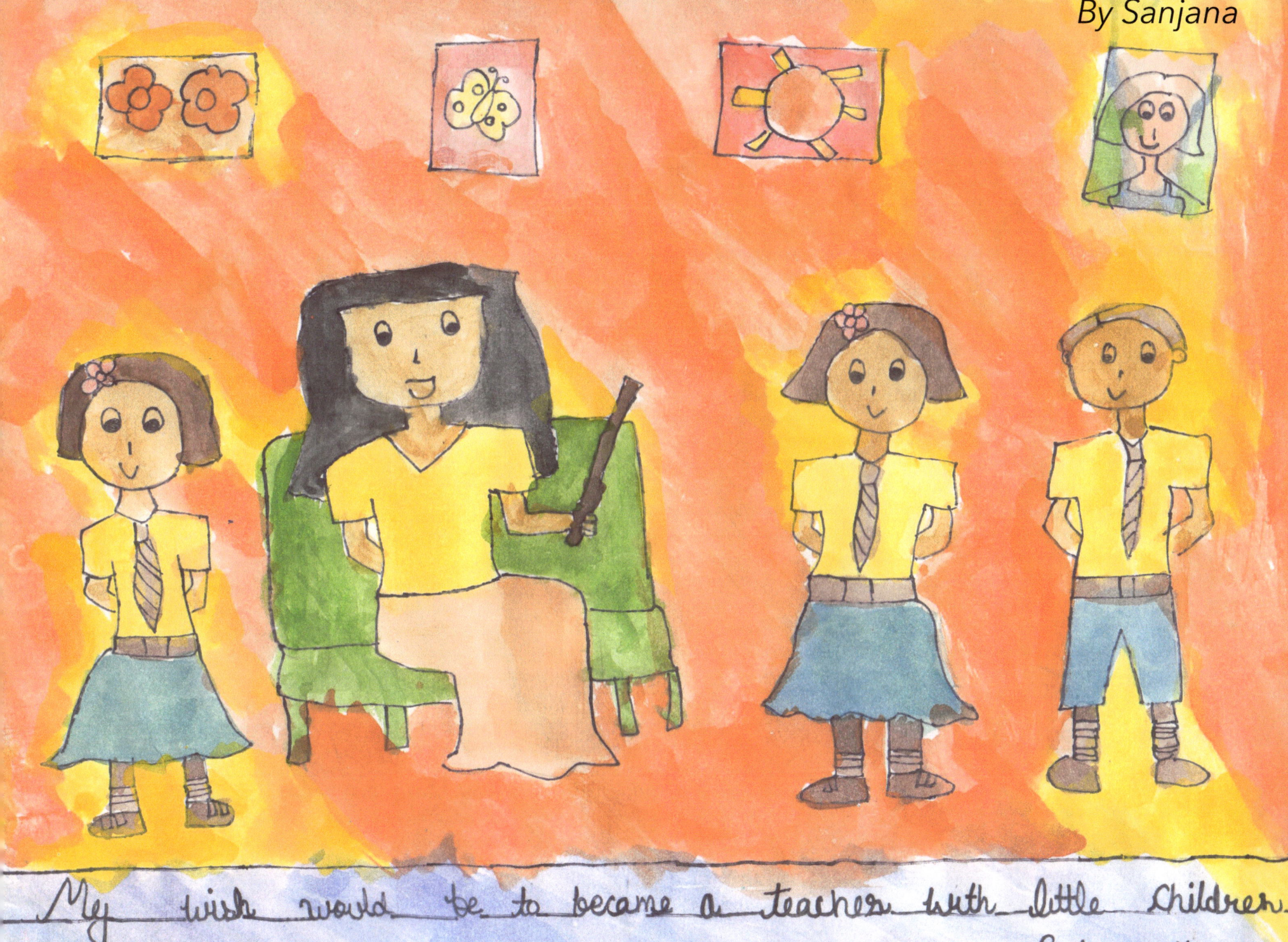

Acknowledgements

I would like to thank, with deep, heart-felt appreciation and gratitude...

♥ The students, teachers and Principal of Aikiyam School, Kuilapalayam, Auroville, South India…. for the support and freedom provided to me and for the infinite creativity, boundless energy and imagination displayed by all the village children… especially, the first time authors and artists. Creating books by kids for kids was their idea, specifically of two young boys, who wanted to create an ABC Book for the youngest children to learn the alphabet. This is where Integral Art and Literacy came together to give birth to this wonderful project.

♥ The Sri Aurobindo Ashram, Delhi Branch, New Delhi, India and Madhuban, Uttarakhand, North India whose Village Outreach program enabled me to guide and inspire both students and teachers according to the philosophy and practices of Integral Art (Integral Education and Art Therapy), in addition to providing the art space and materials that has enabled Village Voices to continue blooming.

♥ The students, teachers and Principal of Sunrise Public School, in Talla Ramgarh Uttarakhand…whose appreciation for art , creativity and the enhancement of social , emotional and intellectual development was always expressed with great enthusiasm and joy.

♥ Foundation for World Education… through funds provided by a grant which supports Integral Education, awarded to the Sri Aurobindo Ashram Delhi Branch, graphic design work on four Village Voices books was able to begin, in order to prepare for publishing.

♥ Anthea Guinness of Salt River Publishing who upon her very first and only encounter with Village Voices, embraced the project with open arms and a huge heart and provided fresh ideas, design, expansions and directions…www.saltriverpublishing.com

♥ Kartik Gera, graphic designer who is passionate about Children's Literature, is a pleasure to work with and has the patience to deal with my lack of technological skills.

SALT RIVER

Salt River Publishing believes in encouraging artists and
publishing professionals to come together and reach their
empowered "Yes!"
Salt River was established as a no-profit publisher
with the idea of helping writers, translators, poets,
graphic artists and photographers bring their work into
publishable form.
We provide links to a range of publishing professionals
who offer services for anybody with a book in the making.
And we publish books that inspire and encourage,
including children's books and books that deepen the understanding of mysticism.
Do you have one?

www.SaltRiverPublishing.com

READER RESPONSE
TO SALT RIVER BOOKS

"So many problems are spiritual in nature. And healing often involves finding meaning, purpose and spiritual uplift. The right words at the right time can turn a life around. Therapists and practitioners can point the way for clients who are seeking meaning; writers and artists have an opportunity to share in that work. Thank you, Salt River."

www.ingramcontent.com/pod-product-compliance
Lightning Source LLC
Chambersburg PA
CBHW050413180526
45159CB00005B/2253